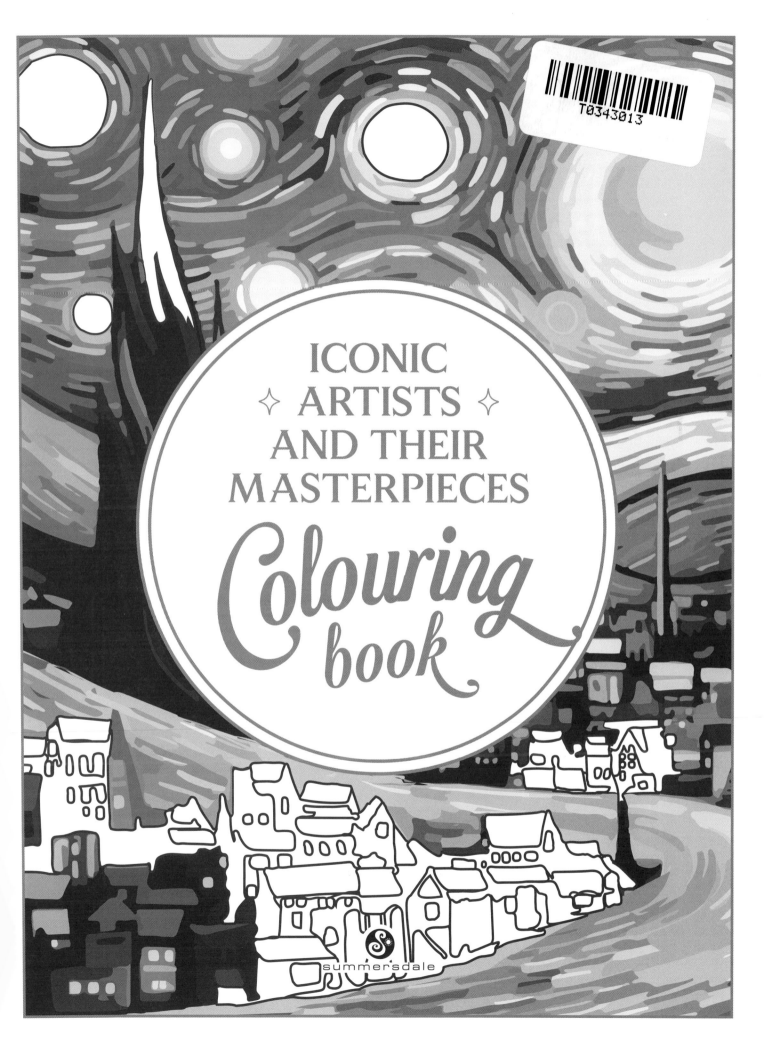

ICONIC
✧ ARTISTS ✧
AND THEIR
MASTERPIECES

Colouring book

summersdale

ICONIC ARTISTS AND THEIR MASTERPIECES: THE COLOURING BOOK

First published in Spanish as *Atelier de Arte Para Colorear* by FERA, 2021

An Hachette UK Company
www.hachette.co.uk

Summersdale Publishers
Part of Octopus Publishing Group Limited
Carmelite House
50 Victoria Embankment
LONDON
EC4Y 0DZ
UK

www.summersdale.com

Printed and bound in Poland

ISBN: 978-1-83799-332-1

Substantial discounts on bulk quantities of Summersdale books are available to corporations, professional associations and other organizations. For details contact general enquiries: telephone: +44 (0) 1243 771107 or email: enquiries@summersdale.com.

This colouring book invites you to explore a hand-picked selection of iconic artworks from a fresh new perspective. Colouring may seem a simple act but, once we find the time to do it, it bonds us with the creative moment.

From Sandro Botticelli's *The Birth of Venus* to Claude Monet's *Water Lilies*, colouring the most famous masterpieces by each artist connects us with the messages behind their great works. What are you waiting for? Delve in for a creative experience like no other.

SANDRO BOTTICELLI
(1445–1510)

Sandro Botticelli, a painter from the Italian *Quattrocento* – the cultural and artistic movement during the transition from the Medieval period into the Renaissance – has gone down in history thanks to his famous paintings of mythological scenes. His great aptitude for drawing, coupled with his delicate and refined use of colour, result in a harmonious combination of rarely seen beauty.

The Medici family – rulers of Florence and great patrons of the arts – sponsored Botticelli, which earned him his status as an artist. His works *Primavera* (meaning "Spring") and *The Birth of Venus* are Renaissance hallmarks. However, this Italian artist's legacy was underappreciated for years, until pre-Raphaelites rediscovered his work in the nineteenth century.

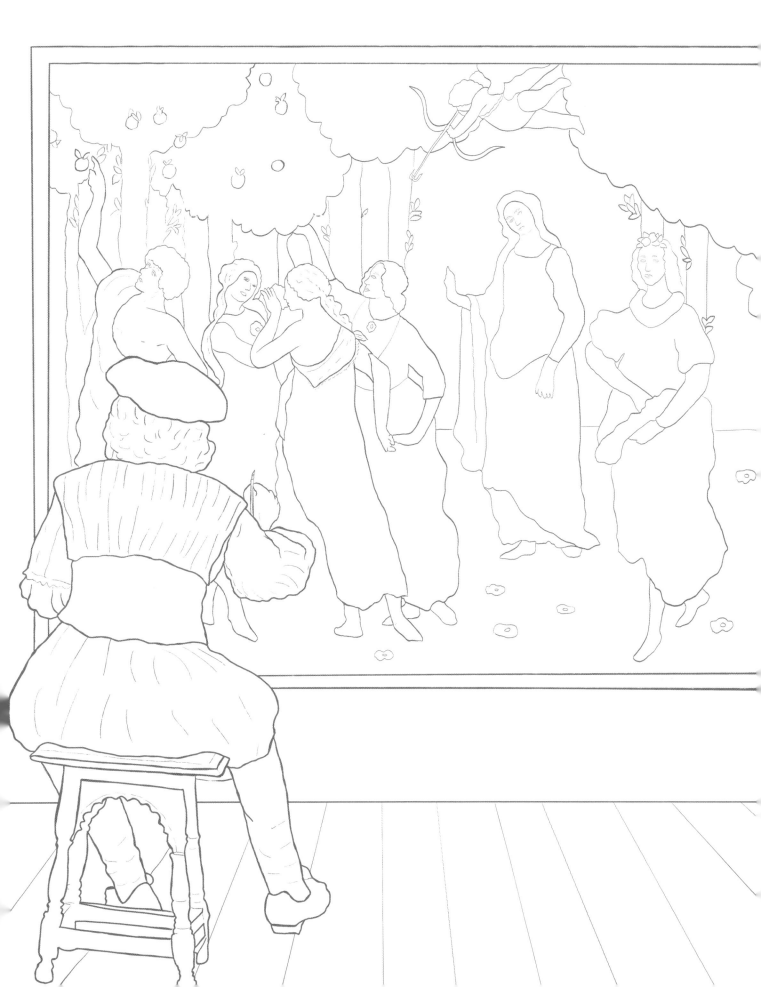

THE BIRTH OF VENUS

The subject of this painting is a naked depiction of the Roman goddess of love, Venus, standing on a seashell, emerging from the sea. She looks calm and her figure is in *contrapposto* pose. On the left, the Roman god of the winds, Aiolos, blows her to shore; on the right, a nymph awaits to cover her.

This painting is the realization of Botticelli's great aptitude for drawing and use of colour. The composition is beautiful and gentle, but also bold, showing a full female nude.

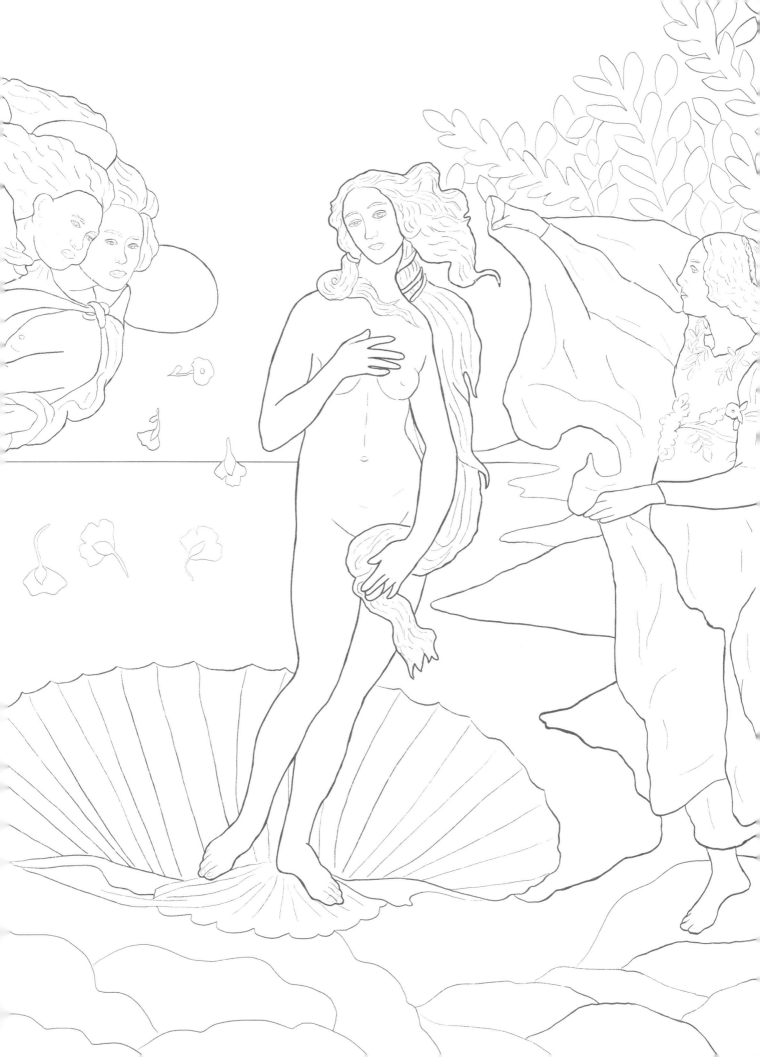

GUAN DAOSHENG
(1262–1319)

Chinese painter Guan Daosheng combined her love of poetry and calligraphy with her talent for painting. She developed a style known as "soul painting" in which she used a soft colour palette with delicate strokes to convey calm and beauty in her landscapes and portraits.

In a time when women's creativity was stifled, Daosheng broke the rules of Ancient China and devoted her time to writing and painting. Her works were collected by the emperors of her country.

BAMBOO PAINTINGS

Bamboo has always represented masculinity in Chinese art, being hard to bend and even harder to break. So, why was a female artist painting these trees in her works? Daosheng challenged the prevailing standards to work in painting, sculpture and calligraphy, and instead of depicting bamboo in isolation, as was the practice, she added them to typical Chinese landscapes.

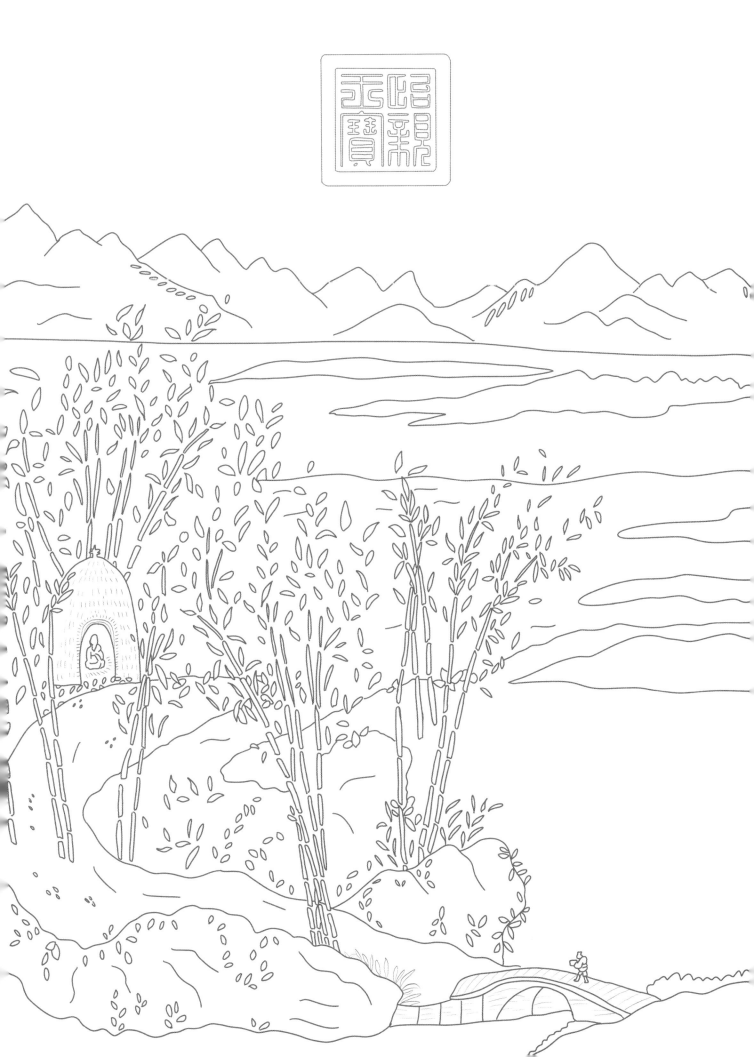

MICHELANGELO BUONARROTI
(1475–1564)

A painter, sculptor, poet and architect, Michelangelo Buonarroti was a versatile man and one of the big names of the Italian Renaissance. In Florence, he was called *Il Divino* ("the divine one") because he sought perfection in everything he did, and he worked obsessively day and night to achieve detailed precision. A glance at the frescoes in the Sistine Chapel is enough to admire his artistic genius.

Michelangelo was chosen by the Church to paint extremely important works. His mastery was such that his shabby appearance and hot temper were overlooked. It's hard not to feel moved when looking at this creative genius's works.

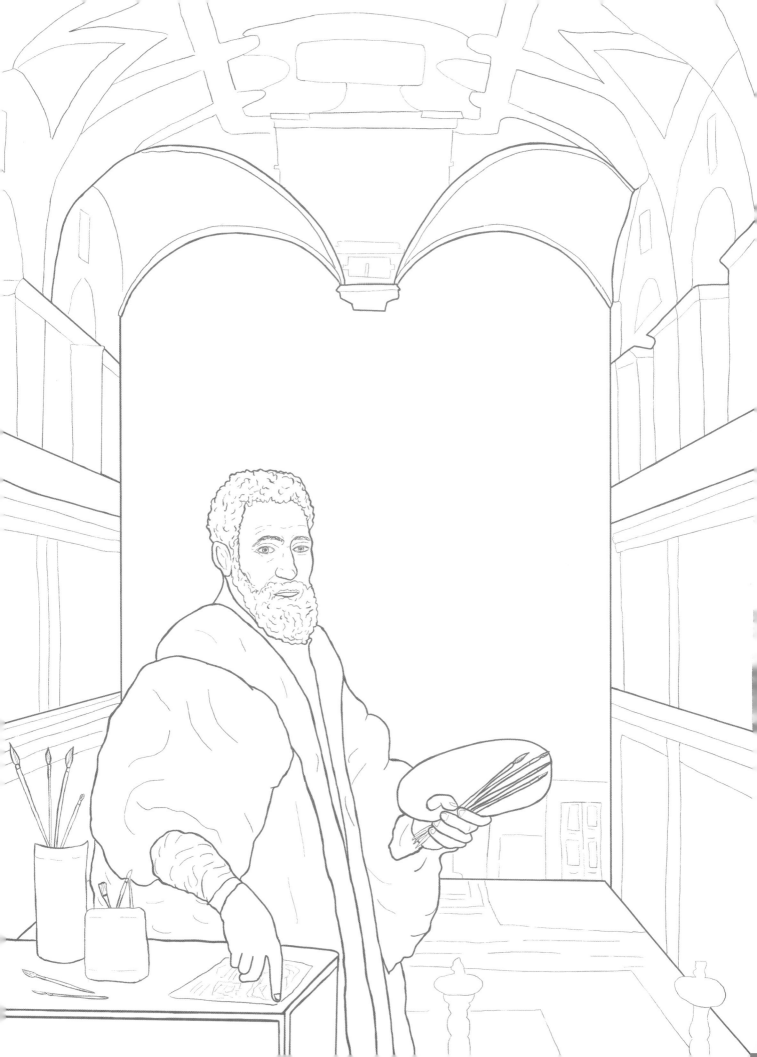

DAVID

The block of marble out of which Michelangelo carved *David* was called "the giant" because of its enormity. Only an exquisite artist was capable of working with it, and Michelangelo rose to the challenge when he was 26 years old. The 5-metre-tall sculpture shows Michelangelo's anatomic knowledge. In this naked figure of idealized beauty, each detail of the body was meticulously carved.

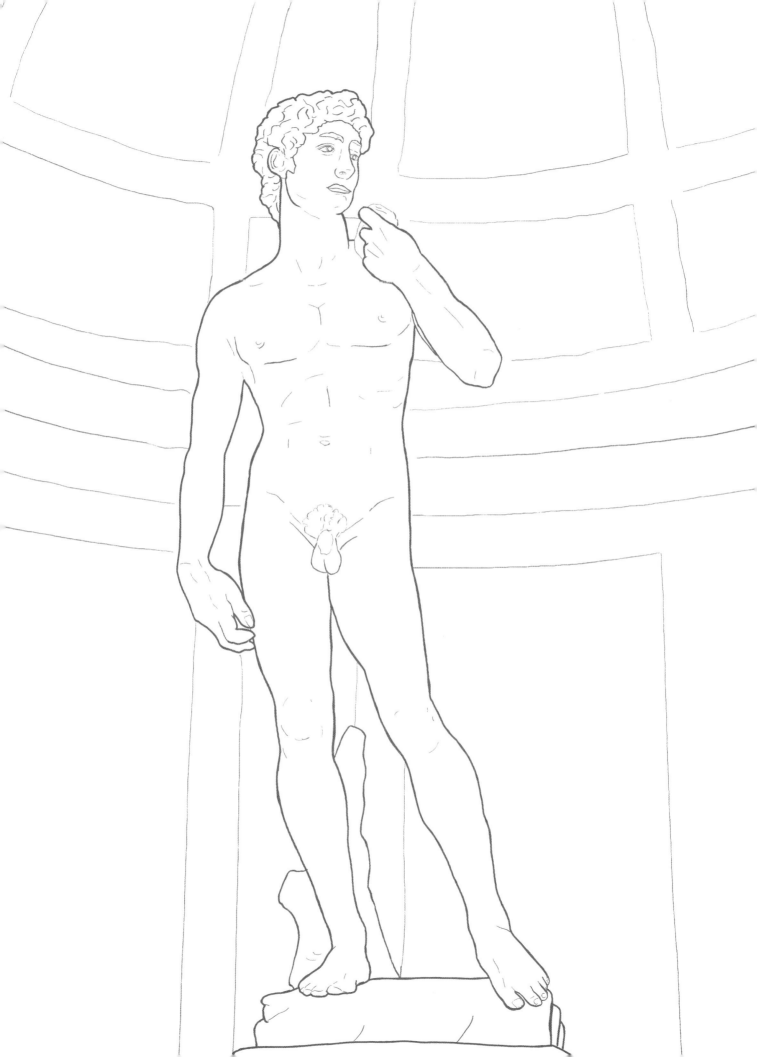

DIEGO VELÁZQUEZ
(1599–1660)

Diego Velázquez was revered by colleagues as the greatest painter in history. Although Velázquez was born in Seville, he spent most of his career in Madrid, where his Spanish Baroque style emerged. He became a painter in King Philip IV's court, painting portraits for the royal family and decorating their residences.

Velázquez was a skilful artist, deeply influenced by his Italian Baroque contemporaries. He was a meticulous observer and creator of great works of realism, and his portraits are recognized for their sombre colour palette. His style paved the way for The Impressionists, who were inspired by his loose brushstrokes and use of light.

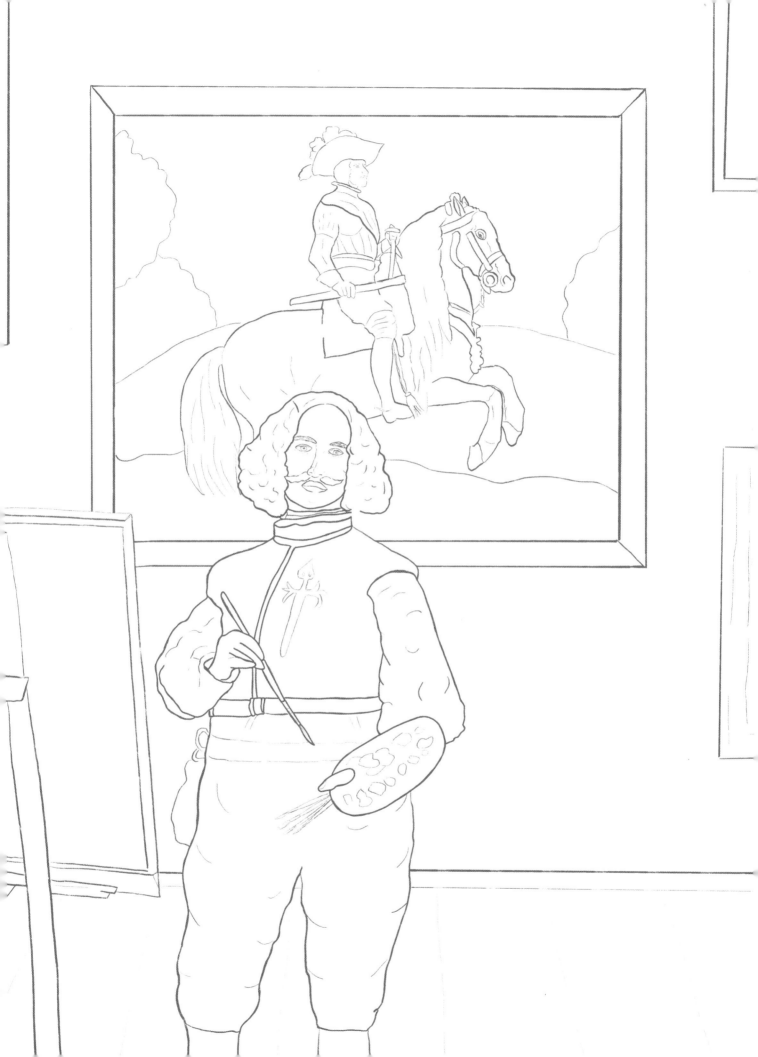

LAS MENINAS

The full composition shows the most eccentric portrait ever painted, *Las Meninas* ("The Ladies-in-Waiting"). It is a huge work of art – reaching almost 3 metres in height and width – portraying Philip IV's family in a new and creative way: unposed, almost as if we are spying on them.

The composition shows the king and queen reflected in a mirror, Infanta Margaret, her ladies-in-waiting attending to her, a jester and Velázquez himself standing behind his canvas. This collective portrait displays the Spanish artist's creativity and innovation in introducing a whole new style of portraiture.

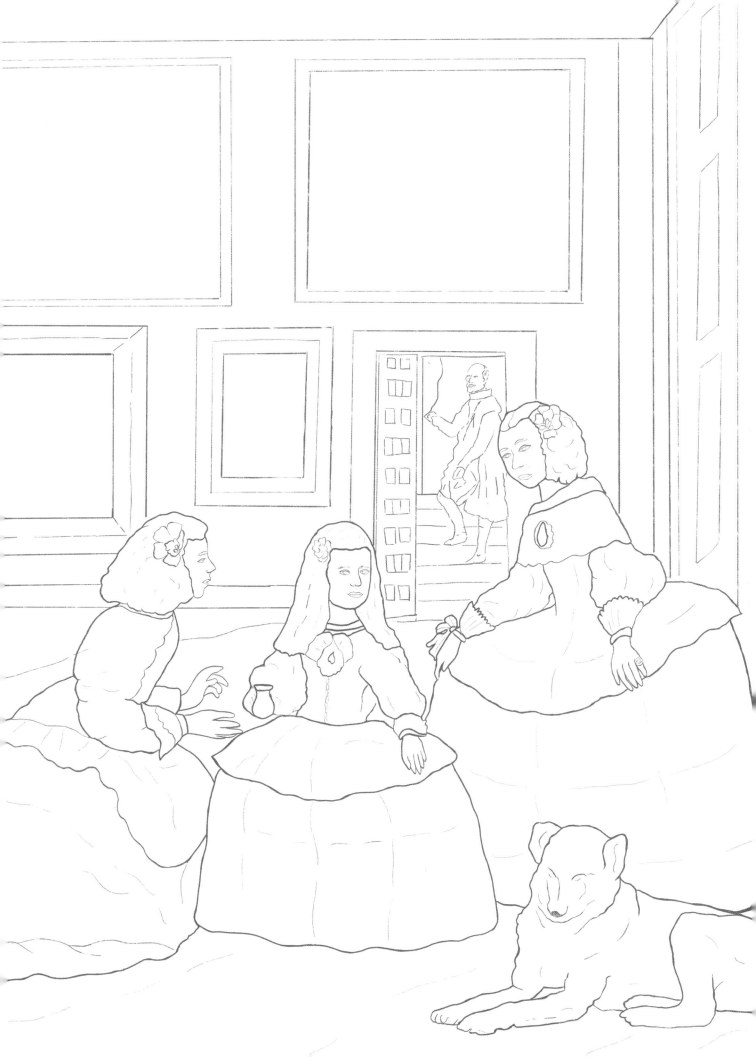

MARY DELANY
(1700–1788)

Mary Delany was born into an aristocratic English family and learned art, music and sewing from a very early age. In the early 1770s, at the age of 70, she started creating what she called "paper mosaics" – a collection of small works made from paper flowers of different weight and textures. Mary worked without sketches; using scissors, she simply cut out the shapes she desired and placed them on a dark background to highlight the composition.

Over the course of 15 years, Delany created almost a thousand of these collages, but she was forced to stop when her eyesight started to fail. Not only does her legacy include beautiful and delicate works of art, but they are also impressive for their botanic precision.

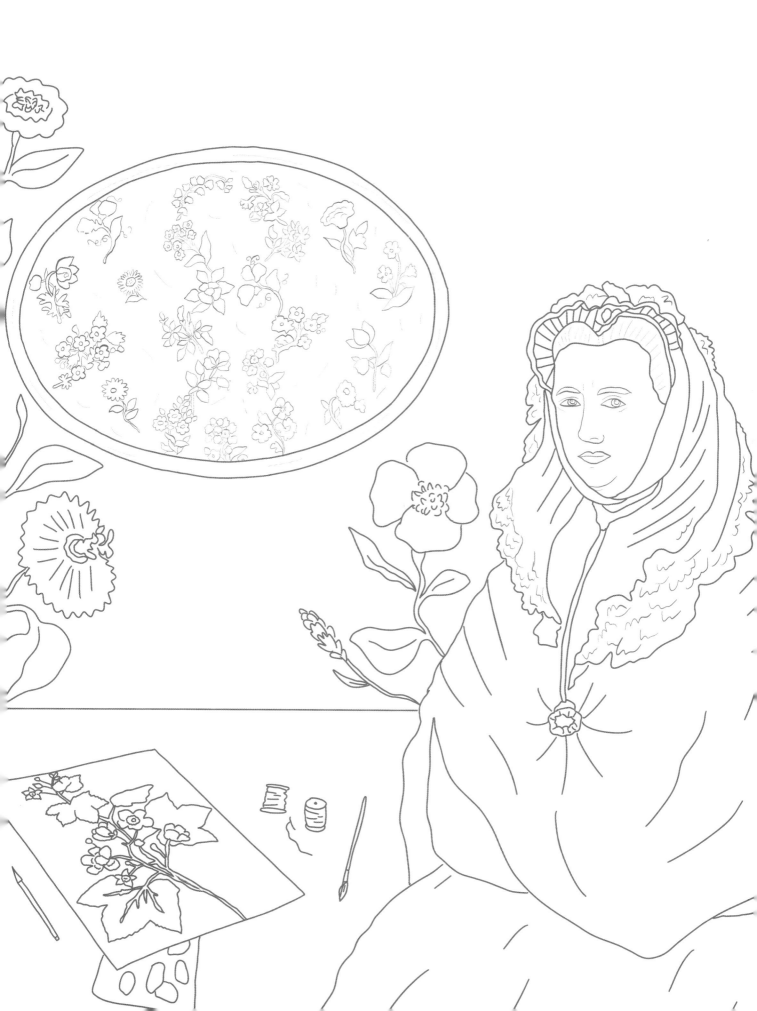

NYCTANTHES SAMBAC

Mary Delany was one of the first Western artists to practise collage, a popular technique among high-class British ladies. Her works were inspired by flowers, which she represented realistically, observing every detail. She used coloured paper scraps complemented by watercolours and black ink for backgrounds. Delany's works also include a notice board with the main flower's name on it.

Mary claims that in her collection, *Flora Delanica*, she "invented a new way of imitating flowers".

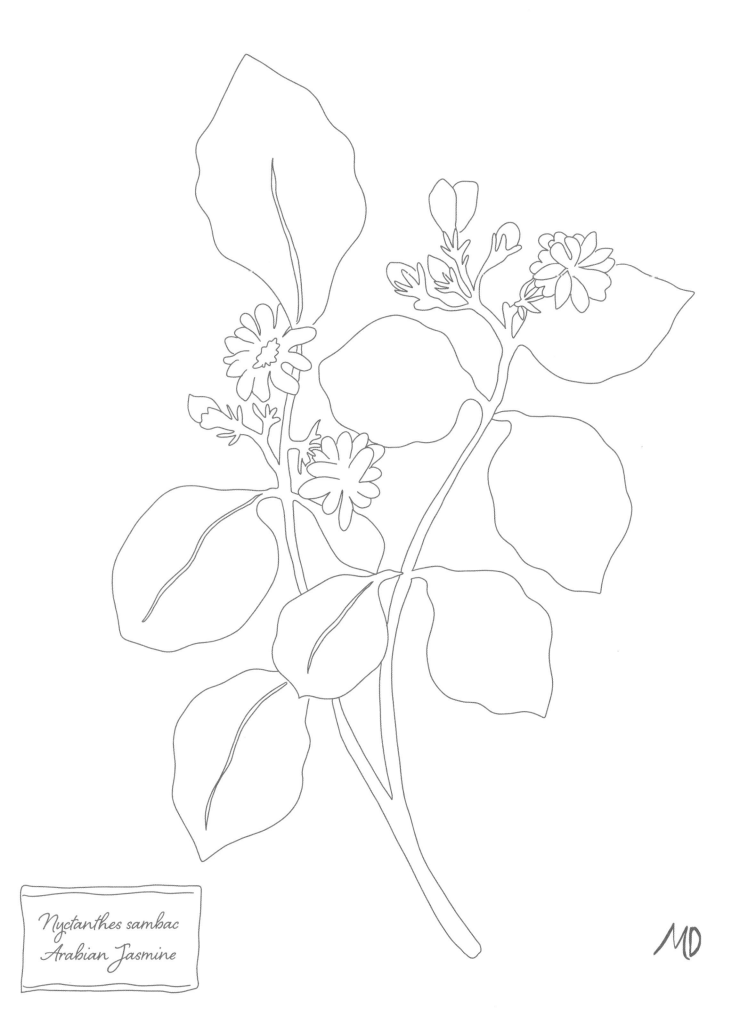

Nyctanthes sambac
Arabian Jasmine

MD

FRANCISCO DE GOYA
(1746–1828)

Francisco de Goya is one of the greatest names in Spanish art and a pioneer in modern art. His paintings include royal portraits, war, nudes and even mythological scenes. He was employed as chief court painter in middle age, which meant being the main artist in the Spanish court – a position held by Diego Velázquez years before.

Apart from his job as a painter, Goya is well-known for his engravings. He created a series of 80 etchings entitled *Los Caprichos* ("The Caprices"), which revealed his commitment to documenting social and political conflicts, as well as his criticisms of Spanish society at the time.

SATURN DEVOURING HIS SON

In this work, Goya chose a Roman mythological scene. Having overthrown his father, Roman god Saturn fears his own descendants will dethrone him. To prevent this from happening, he devours each of them. In this harsh and bloody scene, Goya does not shy away from the gory details.

Saturn Devouring His Son belongs to a series of 14 "black paintings" by this artist, in which both the themes and colours are dark. This series was painted on the walls of the Spanish artist's house.

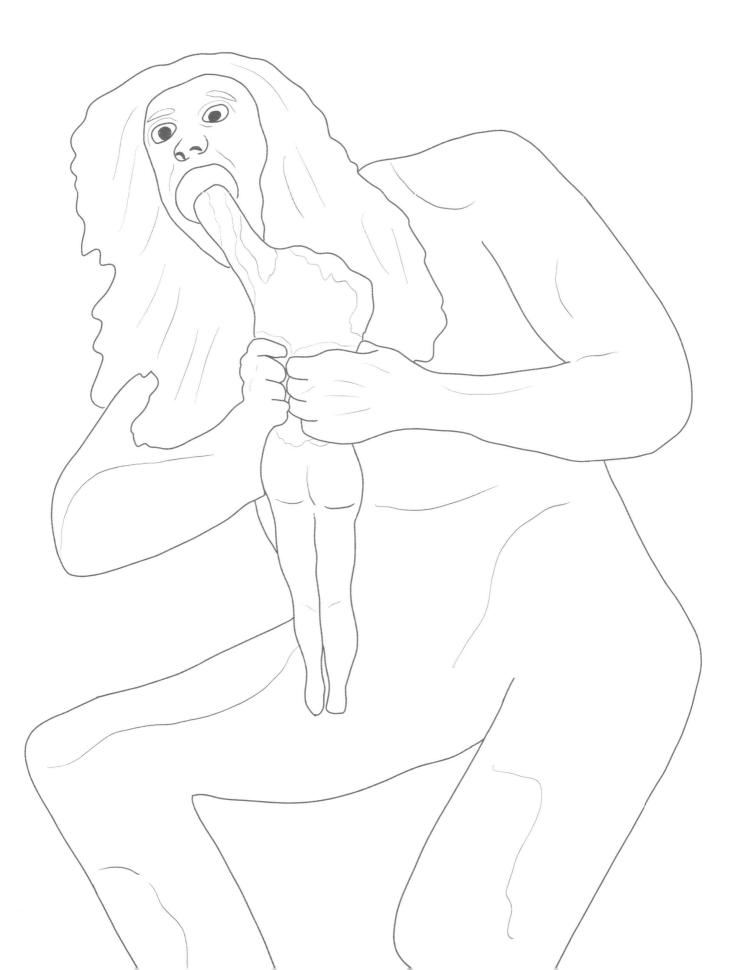

KATSUSHIKA HOKUSAI
(1760–1849)

Katsushika Hokusai was an outstanding Japanese artist from a period known as *Ukiyo-e*, meaning "images from the floating world" – the "floating world" referring to the licensed brothel and theatre districts of Japan's big cities. Hokusai specialized in wood-block engravings of landscapes and everyday life, framing the beauty of nature and the essence of Japanese culture.

Despite calling himself "just an apprentice", Hokusai was the first Japanese artist to exhibit works outside his country. Some of his images, such as *Under the Wave off Kanagawa* (also referred to as *The Great Wave*), have become iconic. Hokusai continued to influence artists many years after his death, as can be seen in works like *The Starry Night* by Vincent van Gogh.

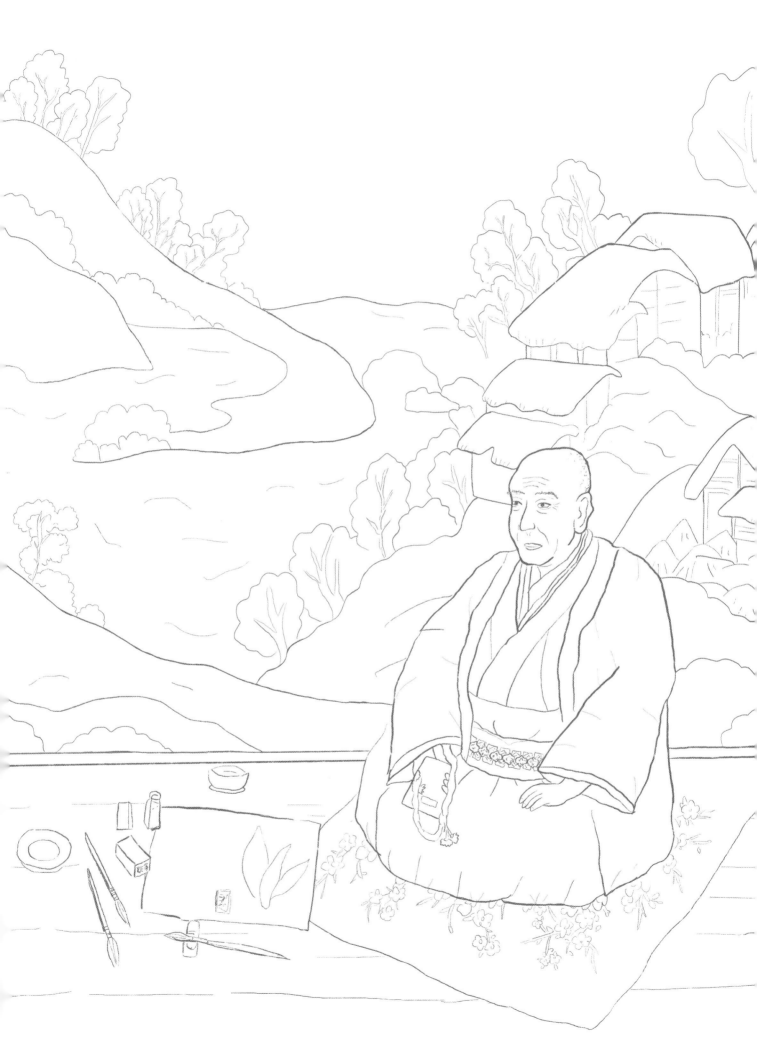

UNDER THE WAVE OFF KANAGAWA

Commonly known as *The Great Wave*, this engraving by Hokusai is seen everywhere today in various formats, from T-shirts to tattoos. Perhaps this is because it captures the brief moment when a giant wave is about to engulf some fishing boats, another example of the immensity of nature and human frailty.

Given that it's an engraving, several versions of this work can be found in The Metropolitan Museum of Art in New York City, The British Museum in London and other cultural spaces.

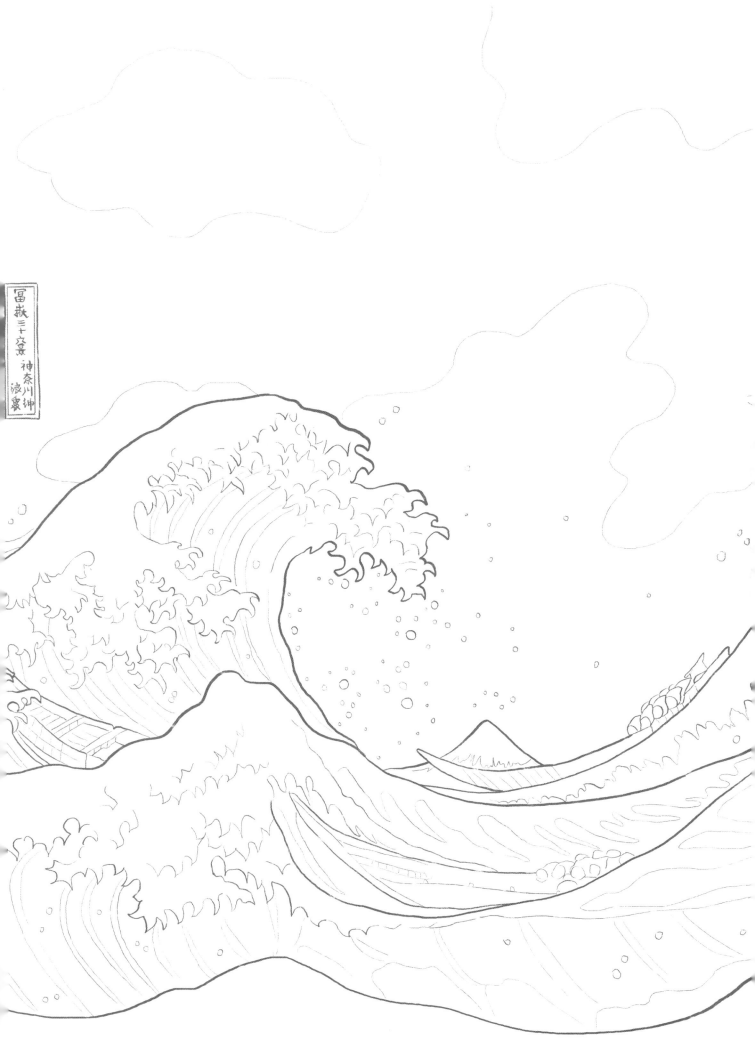

J. M. W. TURNER
(1775–1851)

When he was only 14 years old, J. M. W. Turner began to study at the Royal Academy of Arts in London. He specialized in landscape painting from a Romantic perspective but using precedent-setting approaches. On canvas, Turner highlighted the power and beauty of nature with such expression that his works are truly evocative.

Turner was a key player in the onset of modern art, with his legacy influencing artists like Claude Monet and Mark Rothko, who followed some of Turner's painting styles.

LANDSCAPES

Turner was one of the great Romantic painters. His works are the precursors of Impressionism and abstraction. In each, he took a highly poetic approach using loose, energetic strokes to suggest movement and drama. By making use of a vibrant palette to create highlights within the works, he transformed scenes into highly emotive depictions. To understand Turner, all you need to do is look at his seas and skies.

ROSA BONHEUR
(1822–1899)

Born into a family of artists in Bordeaux, France, Rosa Bonheur moved to Paris when she was a child and grew up learning from the great artists she found in the Louvre. By the age of 19, she was already exhibiting paintings in the Salon, a place rarely frequented by women at the time. Bonheur was an animalier – an artist known for their realistic depictions of animals – and she studied their anatomy obsessively.

Bonheur dared to break the established standards of her time: she wore trousers, which only men wore; smoked cigars; and did not hide her romantic relationships with other women. She went on to become highly respected in the male-dominated art world of the time.

EL CID

Although this work of art was donated
to Museo del Prado in Madrid in 1879,
it remained in the storeroom until 2017.
It was Twitter user Luis Pastor who learned
about this and started a movement under
the hashtag #UnaRosaParaElPrado. Thanks
to him and those who supported his cause,
del Prado decided to hang *El Cid* (meaning
the "lord" or "master") permanently.

The lion in this painting was created
using such a realistic technique
that it appears incredibly lifelike.

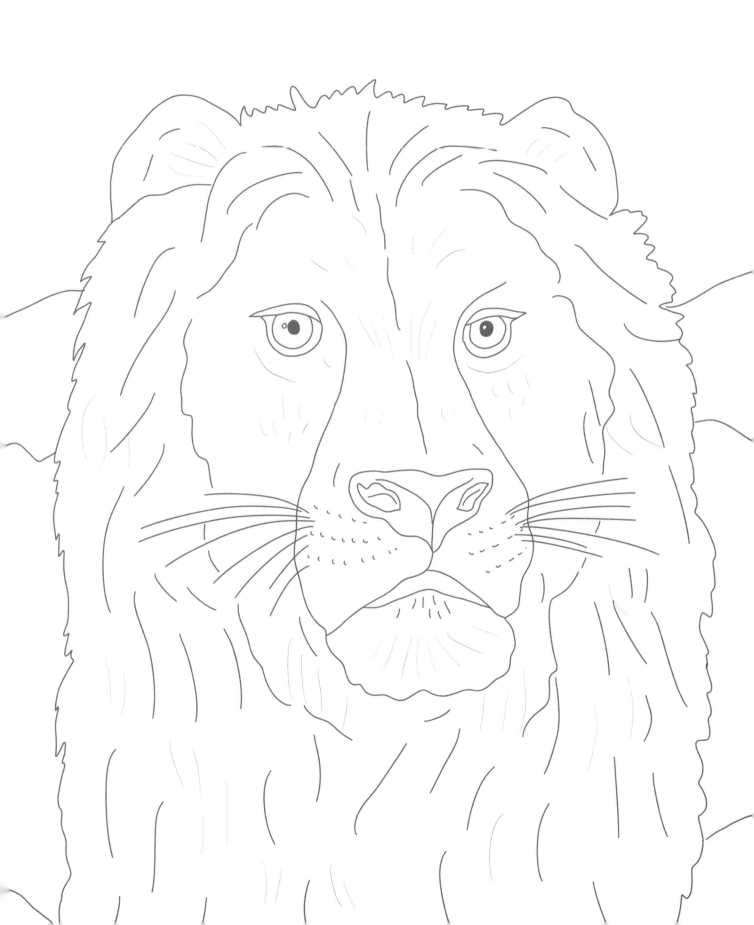

WILLIAM MORRIS
(1834–1896)

William Morris was a British artist, designer, architect and writer who was best known for creating unique prints. His personal style comprises compositions representing intertwined animals, flowers and plants, creating highly aesthetic and organic designs.

Morris was a founder member of the Arts and Crafts movement, championing traditional methods of manufacture in a time of industrialization. His wallpapers, rugs, embroideries and designs are still popular today.

STRAWBERRY THIEF

This is undoubtedly one of Morris's most famous prints. In it, he poetically recreates some birds stealing strawberries, a scene he witnessed from the window of his Oxfordshire house.

Even though it was one of his most expensive designs, *Strawberry Thief* was among the most popular. It was designed for curtains or blankets, because, as Morris once said: "Have nothing in your house that you do not know to be useful, or believe to be beautiful."

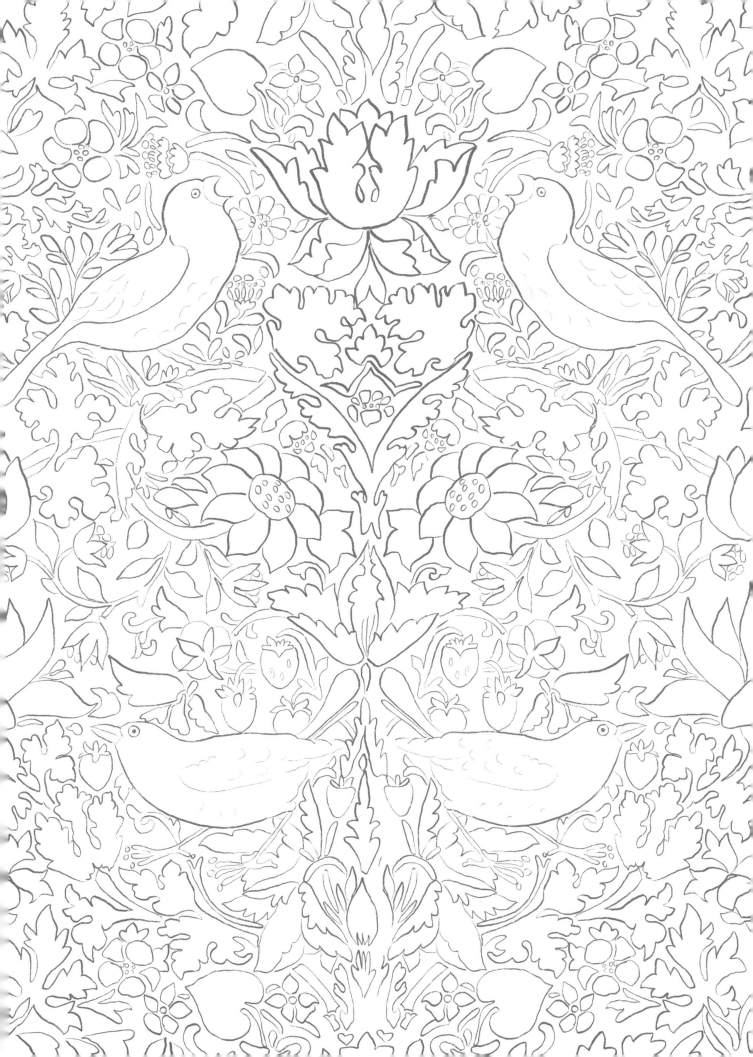

HARRIET POWERS
(1837–1910)

Harriet Powers was an African-American artist famous for her narrative quilts representing everyday life, biblical stories and myths. She embroidered and sewed every patch of fabric in great detail, making valuable artworks and thus preserving African-American culture in times of slavery.

Although Powers never learned to read or write, her quilts are full of highly spiritual ancestral stories; they are icons of folk art from a woman who was born into slavery and emancipated following the American Civil War.

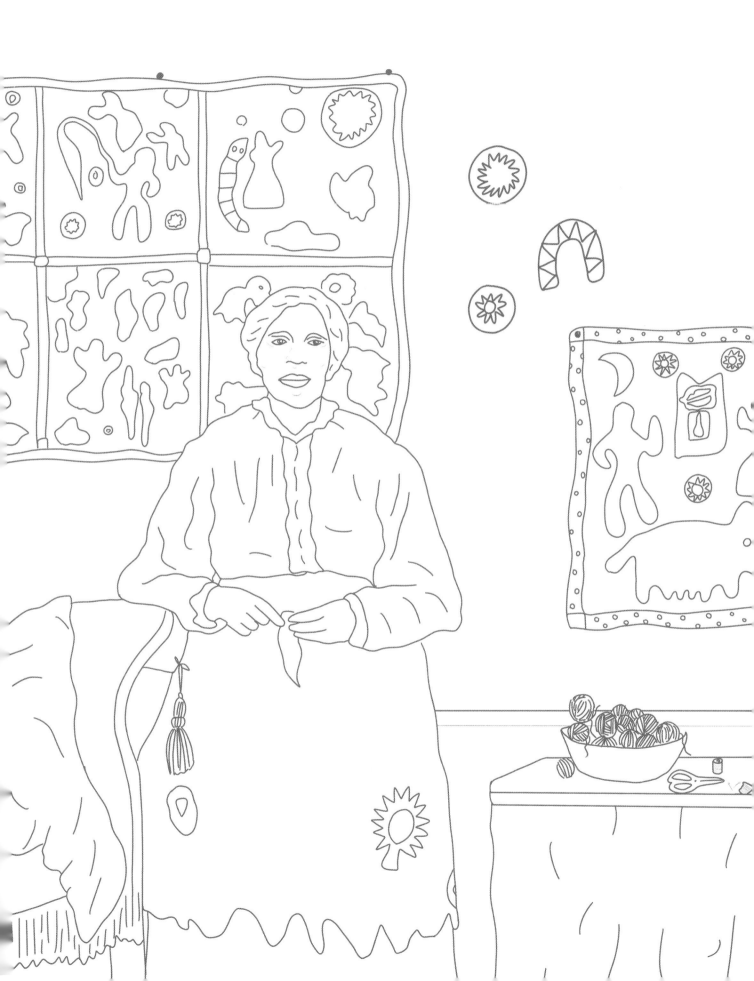

BIBLE QUILT

This quilt, created around 1886, contains
11 biblical scenes separated into panels.
From Adam and Eve in the garden of Eden
to the birth of Christ, Powers sewed, either
by hand or machine, each of the fabric
figures. Only this work and *Pictorial Quilt*
are known to have survived and are on
display in the National Museum of American
History in Washington, D.C. and the Boston
Museum of Fine Arts, respectively.

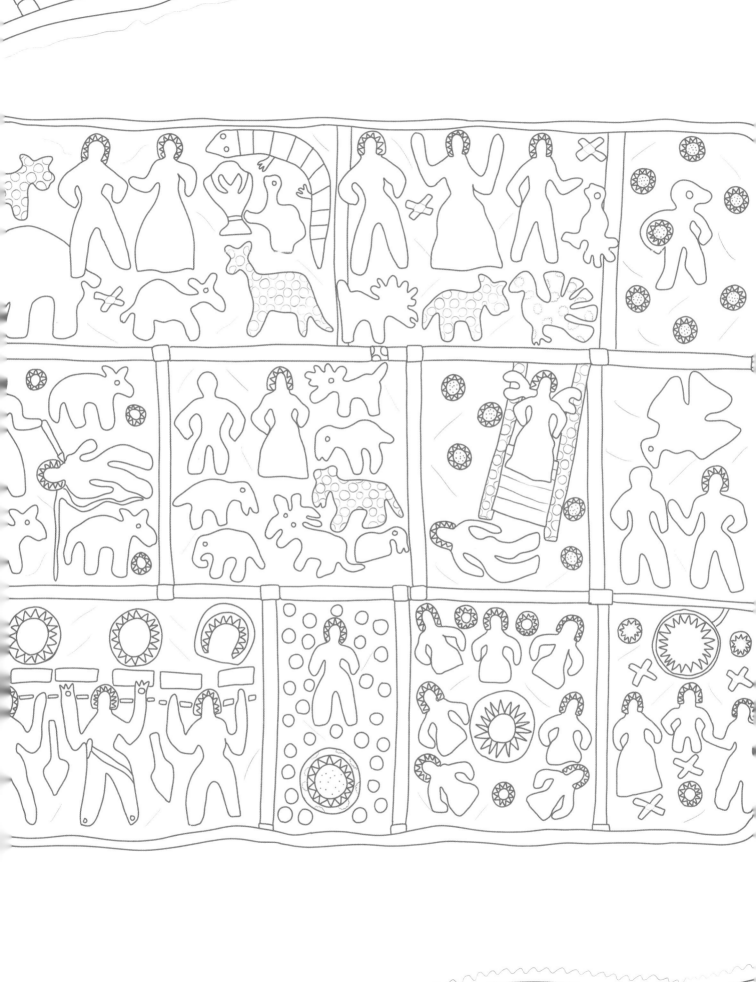

PAUL CÉZANNE
(1839–1906)

A bridge between Impressionism and Cubism, Cézanne was a referent for contemporary artists. Although his colleagues painted "impressions" *en plein air* ("outdoors"), Cézanne chose to stay in his studio creating more structured compositions. By use of his "constructive stroke" based on geometric forms, he sought harmony between shape and colour.

Perspective is quite uncommon in Cézanne's works. He left aside the vanishing point – the point at which receding parallel lines appear to converge – and started representing objects from multiple angles at the same time. This meant disrupting the artistic standards of the time and paved the way for the development of Cubism.

THE BASKET
OF APPLES

Still life was the great theme Cézanne studied in his artistic life. After seeing *Still Life with Apples*, twentieth-century English writer Virginia Woolf wrote: "Imagine snow falling outside, a wind like there is in the Tube, an atmosphere of yellow grains of dust, and us all gloating upon these apples. They really are very superb. The longer one looks the larger and heavier and greener and redder they become."

Working with outline and background was Cézanne's great talent, and by complementing this with vibrant colours, he achieved unique works thought to form the bridge between Impressionism and Cubism.

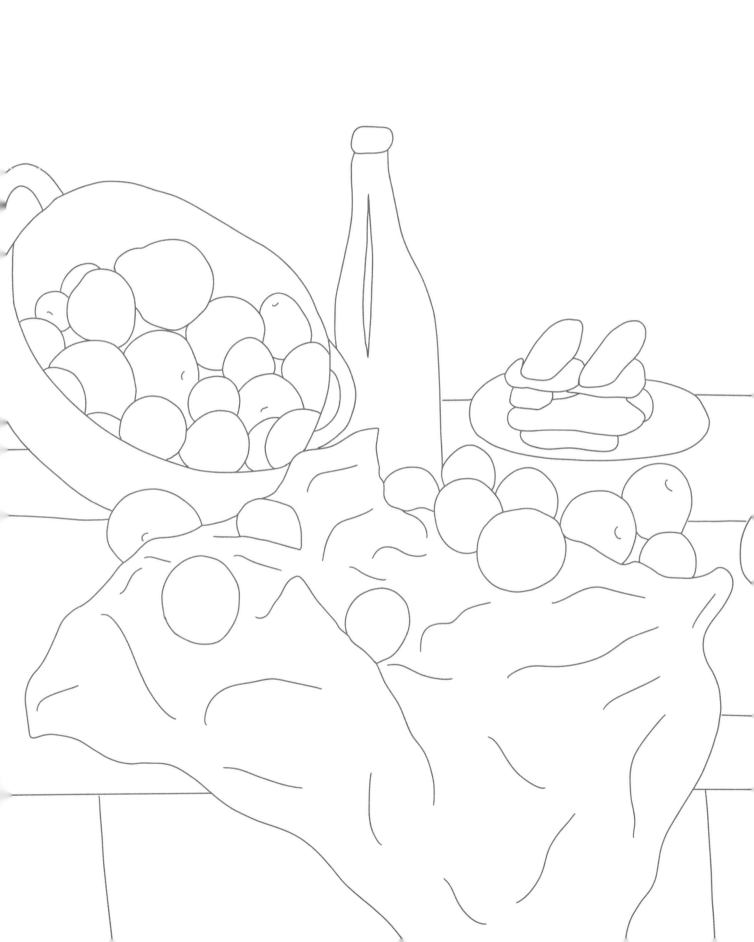

ODILON REDON
(1840–1916)

The relationship French artist Odilon Redon
had with literature from an early age led
him to recreate dream-based worlds in his
works, with fantastic figures, animals, fairies
and monsters. He also found inspiration
in natural landscapes and mythology,
adding a high dose of imagination.

Redon was an outstanding figure in Symbolism,
a movement in which dreams triumphed
over reality. He experimented with oil
painting and pastels, as well as engravings
and charcoal. His complex and emotive
works need to be seen to be believed.

BOUQUET OF FLOWERS

In his adult life, Redon started painting
flower bouquets. His interest in biology,
combined with his symbolic style, led him
to paint a great variety of flowers in vivid
colours surrounded by butterflies.

He said: "I have made an art according
to myself. I have done it with eyes open
to the marvels of the visible world and,
whatever anyone might say, always careful
to obey the laws of nature and life."

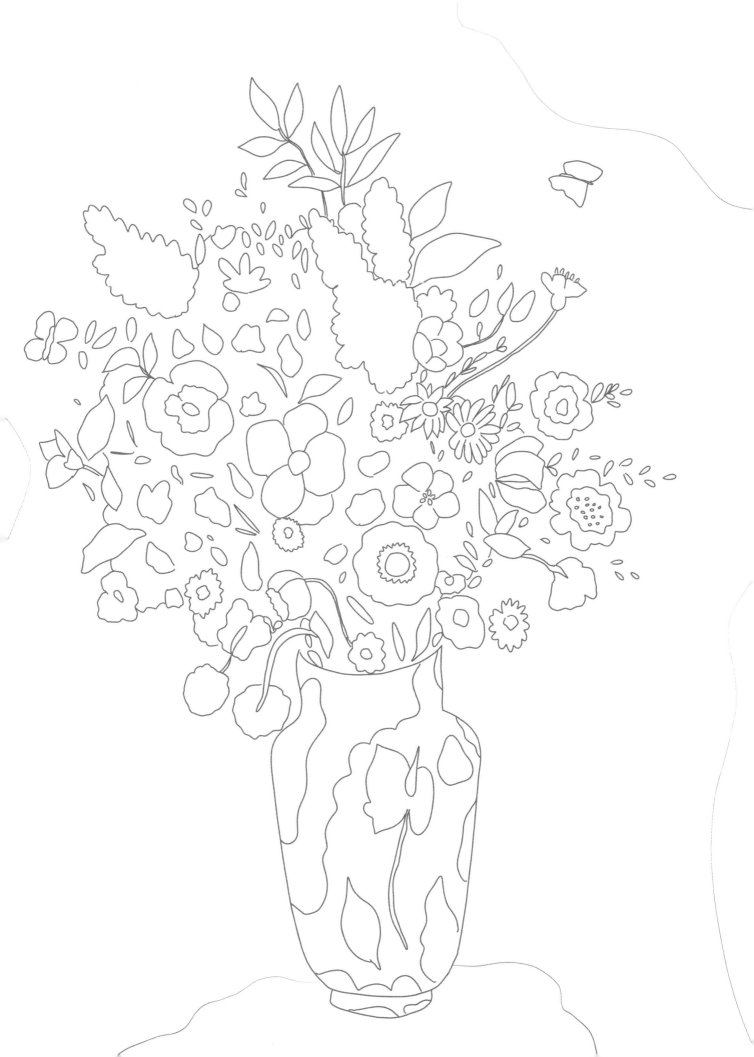

CLAUDE MONET
(1840–1926)

Claude Monet was a French painter and
one of the leaders of the Impressionist
movement, whose works turned a page in
the history of art. It was the time of *l'art pour
l'art* ("art for art's sake") – a belief that art
no longer needed to pursue a moral goal,
but could simply portray everyday life.

Monet's artwork is beautiful from every angle.
Its colours caress the canvas and the brushstrokes
invite us to feel nature. All his life, Monet focused
on the same object: light. He believed that
painting was the most effective way to study it.

He wrote: "The light constantly changes,
and that alters the atmosphere and
beauty of things every minute."

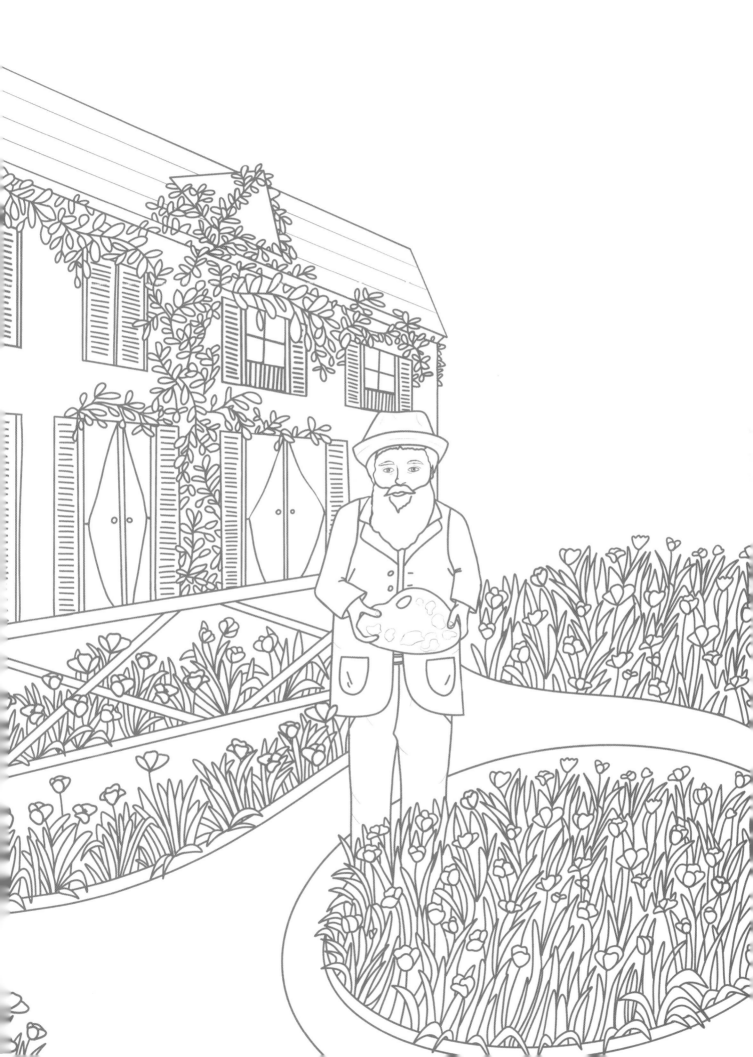

WATER LILIES

After purchasing his house in Giverny, France, Monet built a garden with the landscapes he wanted to depict in his works. He painted more than 250 pictures of water lilies from his own pond and this became the most popular series in Impressionist art.

In these paintings, Monet focused on depicting the reflection of the plants and sky on the water. As he grew older, his paintings became more and more abstract, making it almost impossible to make out the water lilies in the composition.

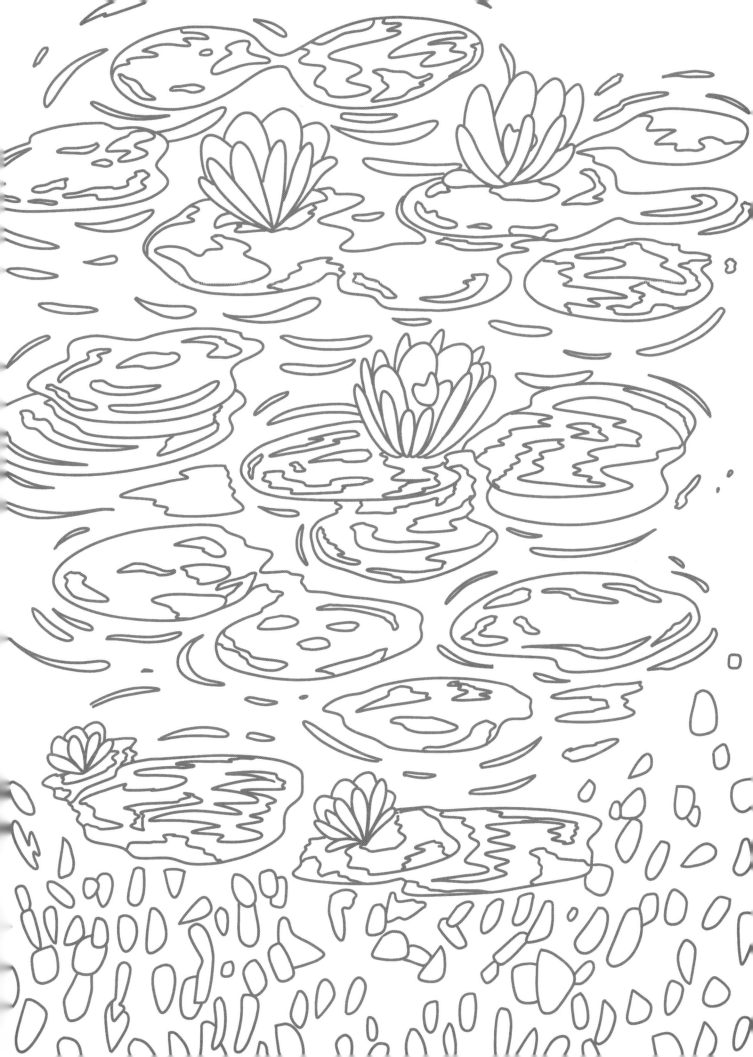

BERTHE MORISOT
(1841–1895)

It was not common to find a woman in Impressionist circles, but French artist Berthe Morisot managed to find a place in that world thanks to her great aptitude for painting. Unlike the rest of her colleagues, who painted *en plein air* – and given that bourgeois women like her did not go out a lot – Berthe specialized in domestic scenes featuring her mother and sisters.

She exhibited her works many times in the Salon in Paris and was highly regarded by her peers. The patriarchal structure of the art world meant Berthe's works were forgotten for years, however this has changed in recent decades.

AFTER LUNCHEON

As was usual in Morisot's works, a woman is the subject of this canvas. This painting, showing a woman sitting at the table after lunch, is a depiction of French bourgeoisie life in the nineteenth century.

After Luncheon was auctioned in 2013 by world-leading auction house Christie's and sold for a record price for Morisot – £7 million, almost three times its estimated value.

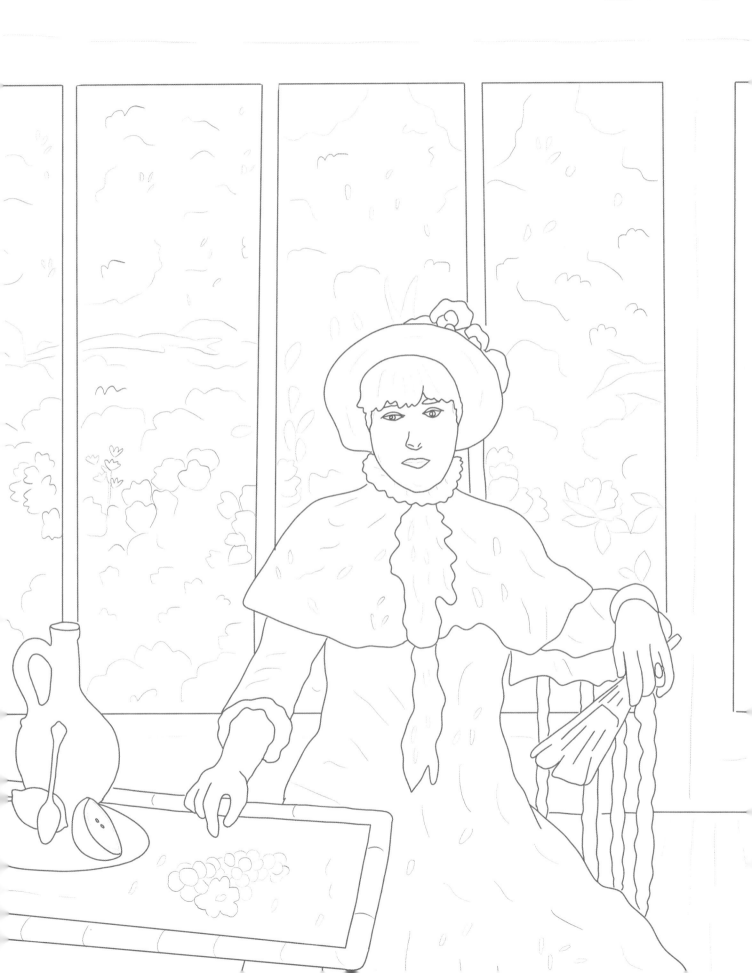

HENRI ROUSSEAU
(1844–1910)

Henri Rousseau started painting when he was almost 50 years old, after quitting his job in customs in Paris. As he never had any academic training, his style is said to be "naive", with simple paintings and little technique. However, Rousseau is remembered for his great works featuring jungle scenes, which, remarkably, he painted without ever leaving the city, instead drawing inspiration from his visits to the botanical gardens of Paris.

While critics made fun of Rousseau, calling him childish, his colleagues looked up to the primitive and dream-based quality of his work.

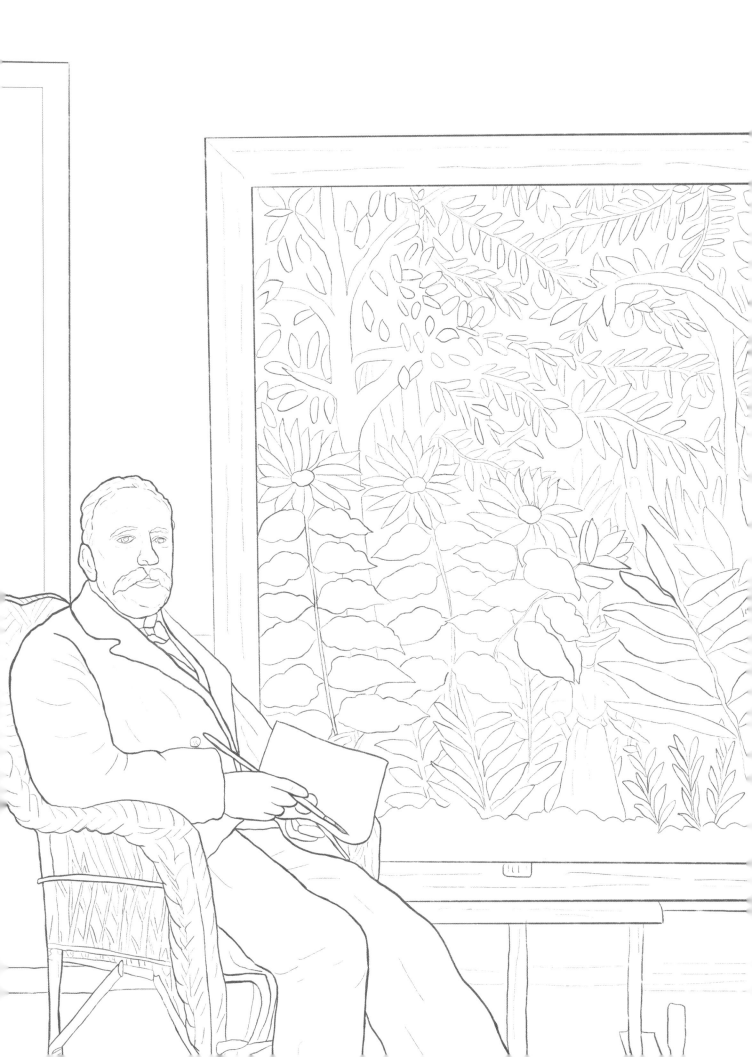

THE DREAM

Rousseau painted this large oil-on-canvas work just before his death. The full composition shows a woman reclining in a lush jungle setting, with animals such as birds, monkeys, lions, an elephant and a snake hiding in the vegetation. The title of this canvas tells us about the dreamlike nature of Rousseau's composition and it had great influence over the Surrealist movement that would start a few years later.

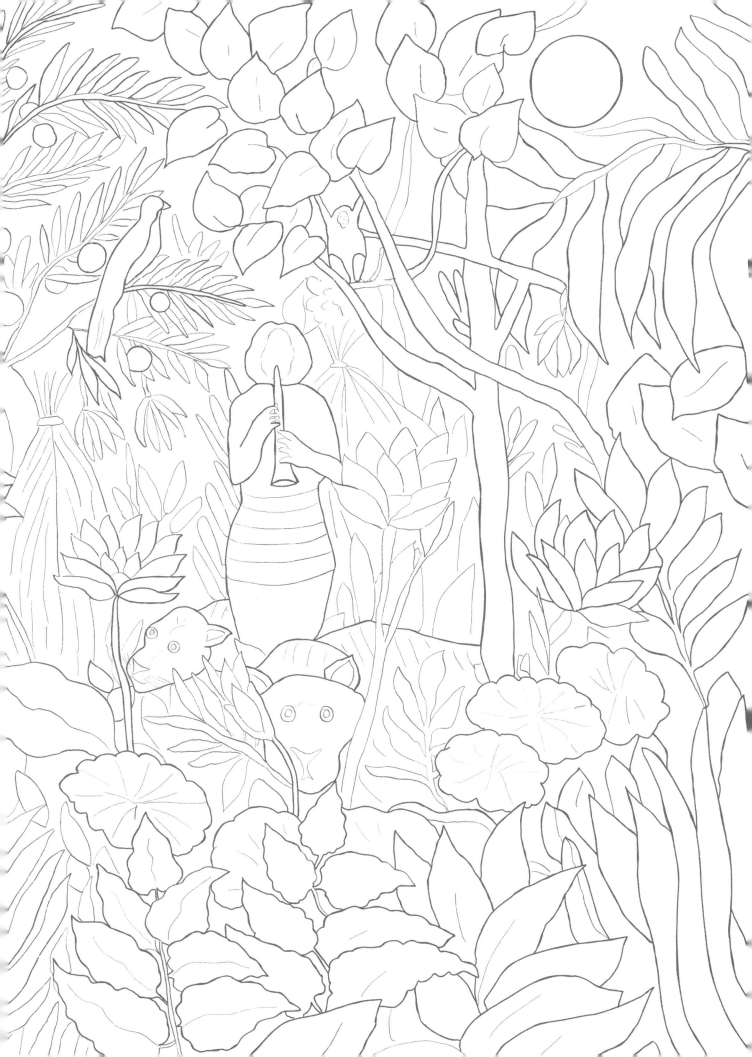

MARY CASSATT
(1844–1926)

Mary Cassatt was an American painter who moved to France to work in the art world. Despite being rejected by the École des Beaux-Arts for being a woman, she trained with other masters and copied the styles of the artists exhibited in European museums.

She met Edgar Degas, an Impressionist artist, and was invited to exhibit with other Impressionists. Much like Berthe Morisot, she would paint scenes of women carrying out daily chores. She chose not to marry, but instead to concentrate on her career, and was an activist for women's rights.

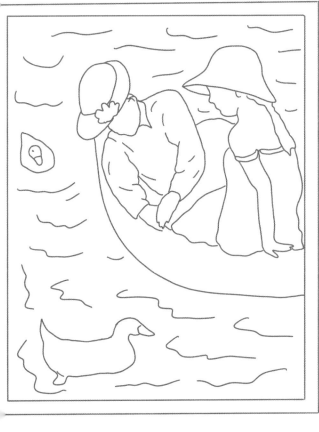

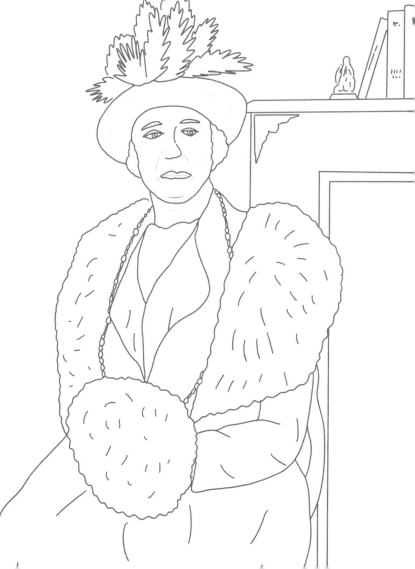

LITTLE GIRL IN A BLUE ARMCHAIR

Like every Impressionist artist, Cassatt's brush moved in agile strokes on the canvas in search of light. The subject of this painting is a young girl. At the time, it was thought rude for a girl to be sitting flopped on a chair like this and the painting was criticized because of it.

Little Girl in a Blue Armchair is now exhibited in the National Gallery of Art in Washington, D.C.

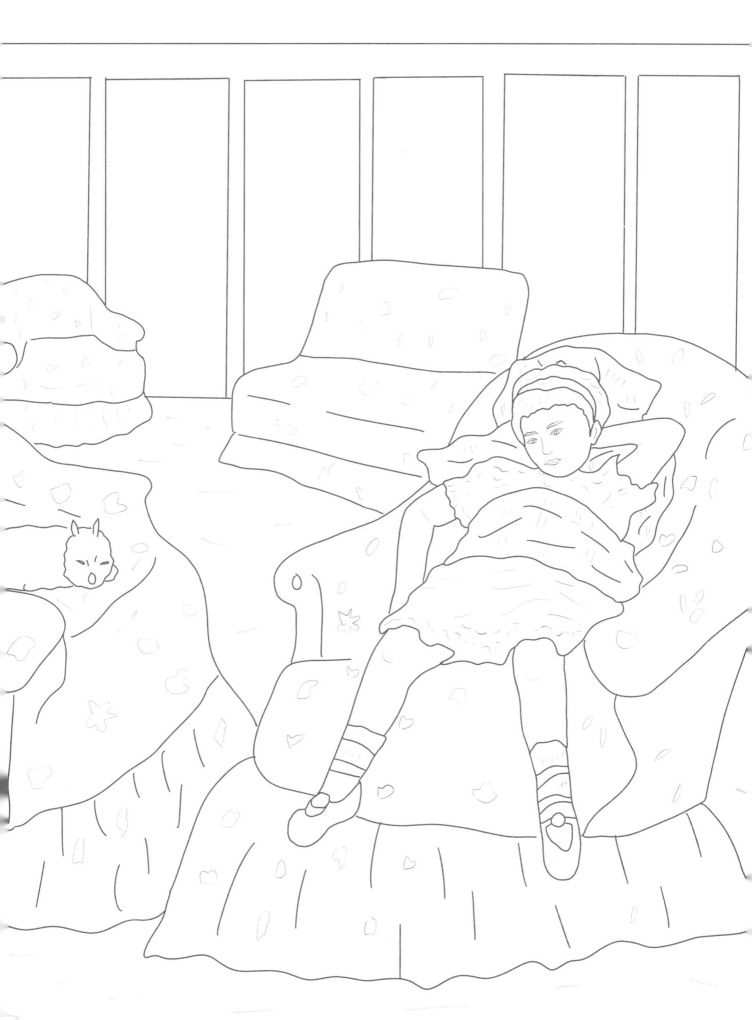

ELLEN HARDING BAKER
(1847–1886)

Ellen Harding Baker was not considered an artist in her time. Born in Iowa in the United States, she taught astronomy in schools and presented at conferences in various institutions. In order to help educate her pupils, she decided to embroider a quilt of the Solar System.

Harding Baker found her place in the history of art because of this work, which today can be found hanging in the Smithsonian Institute in Washington, D.C.

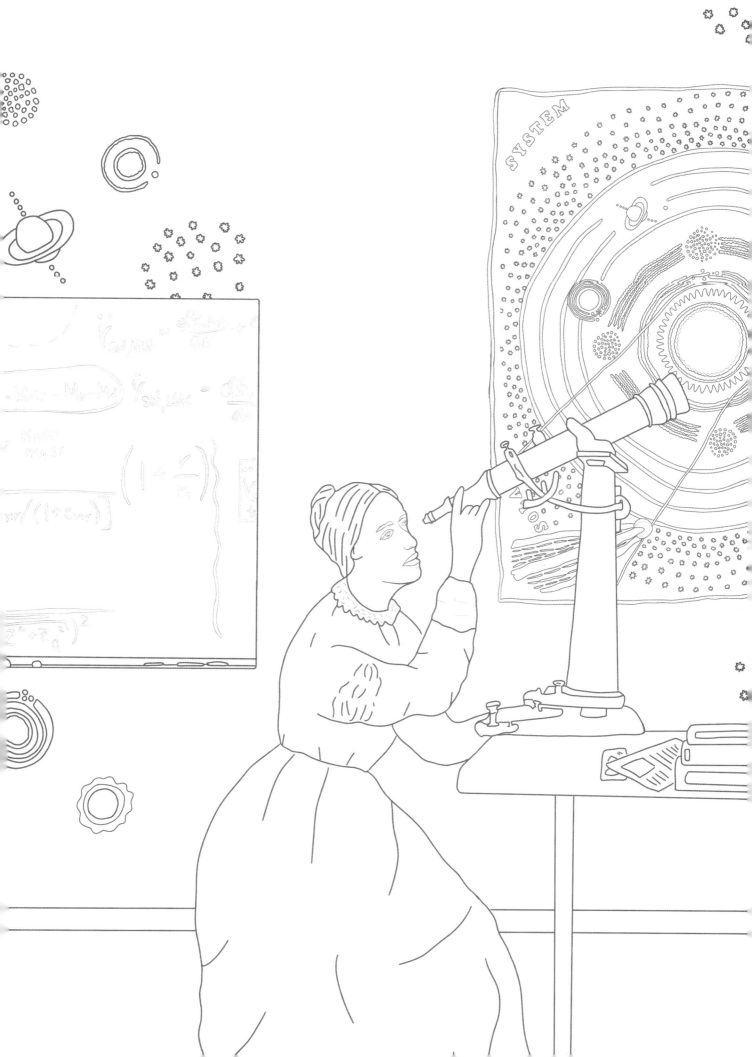

SOLAR SYSTEM

It took Harding Baker seven years to
make this large quilt, which was more than
2 metres tall and almost 3 metres wide.
The quilt shows the Solar System in detail,
as it was depicted in astronomy books at the
time. The Sun sits in the middle and, around
it, the eight planets, an asteroid belt, some
moons and a comet. The quilt is mostly made
of wool, with the stitching in wool or silk.

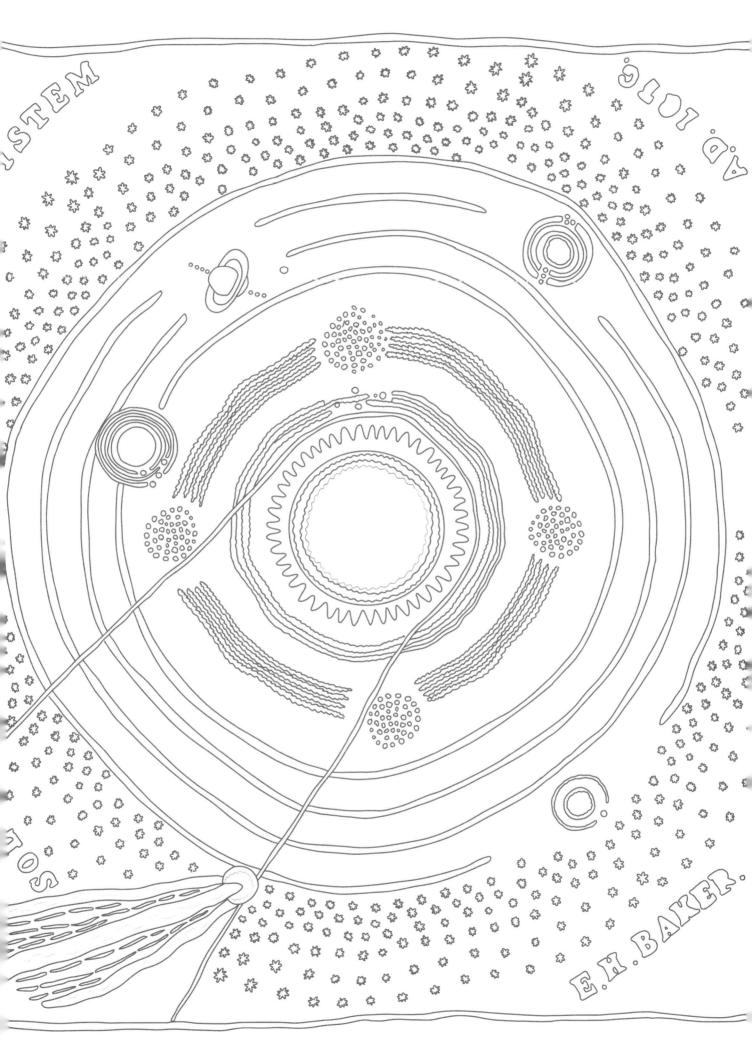

VINCENT van GOGH
(1853–1890)

Nature was Vincent van Gogh's true inspiration. "If you truly love nature, you will find beauty everywhere," he said. He worked *en plein air*, painting frantically in the sunshine. He would go out into the countryside with his easel, canvas and oil paints, walking until he found that magical place to stop and paint. Expressive brushstrokes, loaded with oil paints in ochres, blues and greens, formed van Gogh's personal style. Far from being figurative, his landscapes are imbued with his gestural and subjective gaze.

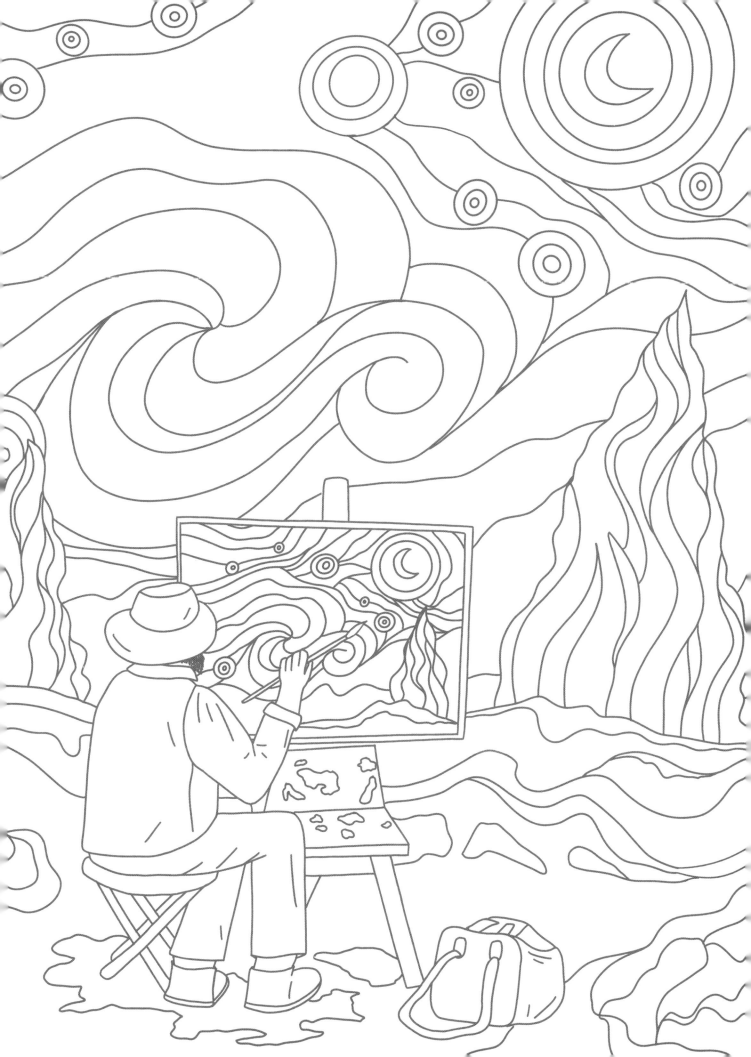

WHEAT FIELD WITH CYPRESSES

Van Gogh was obsessed with cypress trees and he chose to include them in some of his works. In this particular painting, he depicted how the trees shook in the wind.

To create a sense of movement, van Gogh used different types of brushstrokes. He used long unbroken strokes for the sky, and shorter, thicker ones to paint the soil. Just by looking at this painting, it is as though we can hear the sound of the wind blowing through the wheat field.

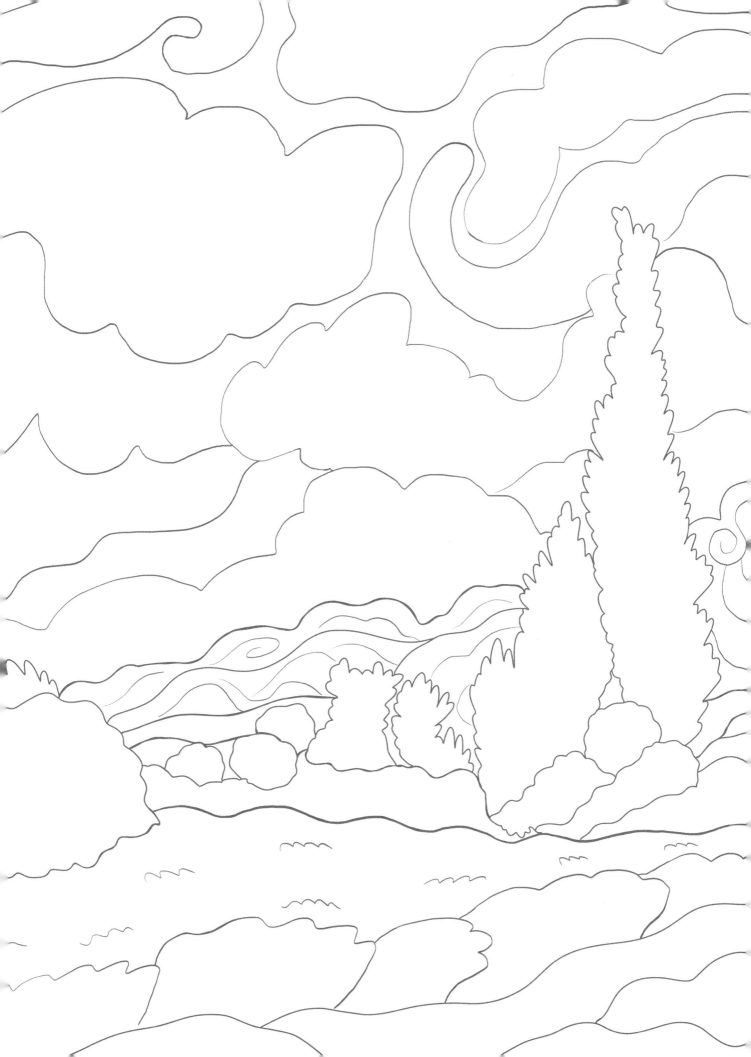

EVELYN DE MORGAN
(1855–1919)

With a clear nod to artists of the Renaissance, especially Sandro Botticelli, Evelyn De Morgan was part of the Pre-Raphaelite movement, which sought to return naturalism and realism to painting.

De Morgan was the first woman to study at the Slade School of Art in London, where she demonstrated a great talent for drawing. She depicted mystical and mythological scenes with a strong atmosphere, creating a sense of indisputable beauty. She chose women as the subjects of her paintings, and was an activist for social and political causes of the time, like women's suffrage.

THE LOVE POTION

A woman performing alchemy is the subject
of this work. She sits in front of a bookshelf
filled with esoteric books and a curtain adorned
with symbols. As in most of De Morgan's
paintings, a female figure is depicted as having
a strong connection with the spiritual world.
Who might this love potion be intended for?

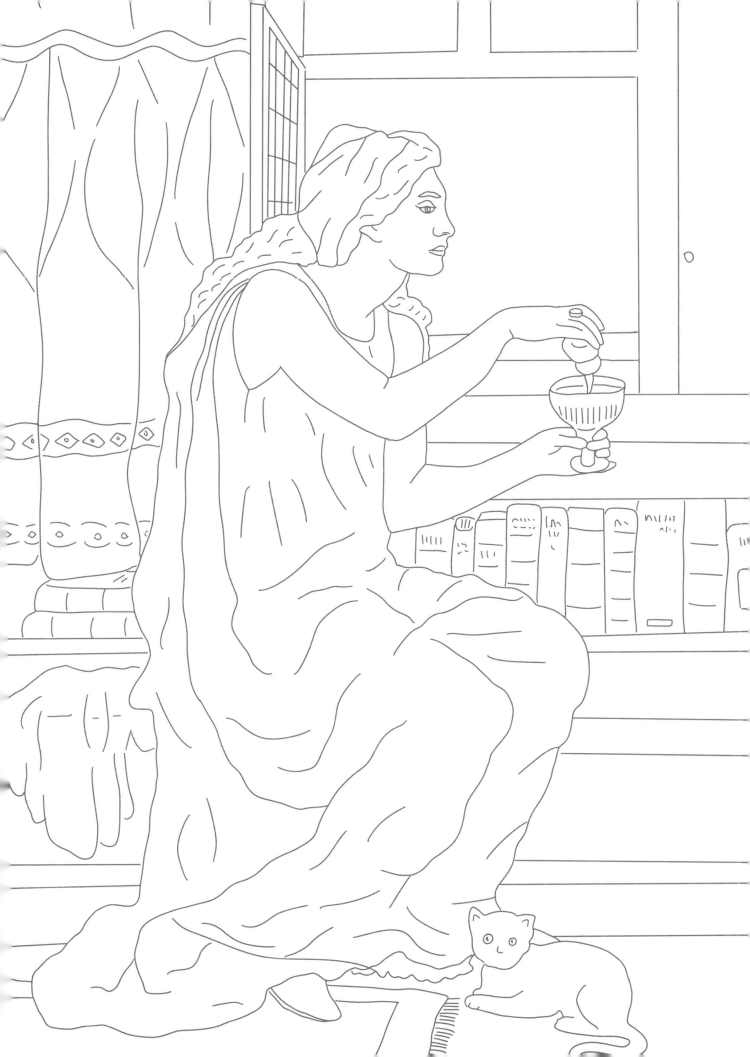

GEORGES SEURAT
(1859–1891)

French artist Georges Seurat had a great interest in colour studies, which resulted in a new artistic movement: Pointillism. Instead of mixing colours in a palette, he would apply them directly to the canvas in the shape of adjacent dots. Seurat achieved a visual effect that, when studied from a distance, allowed a set of independent dots to merge. It is actually the viewer's eye that mixes the colours.

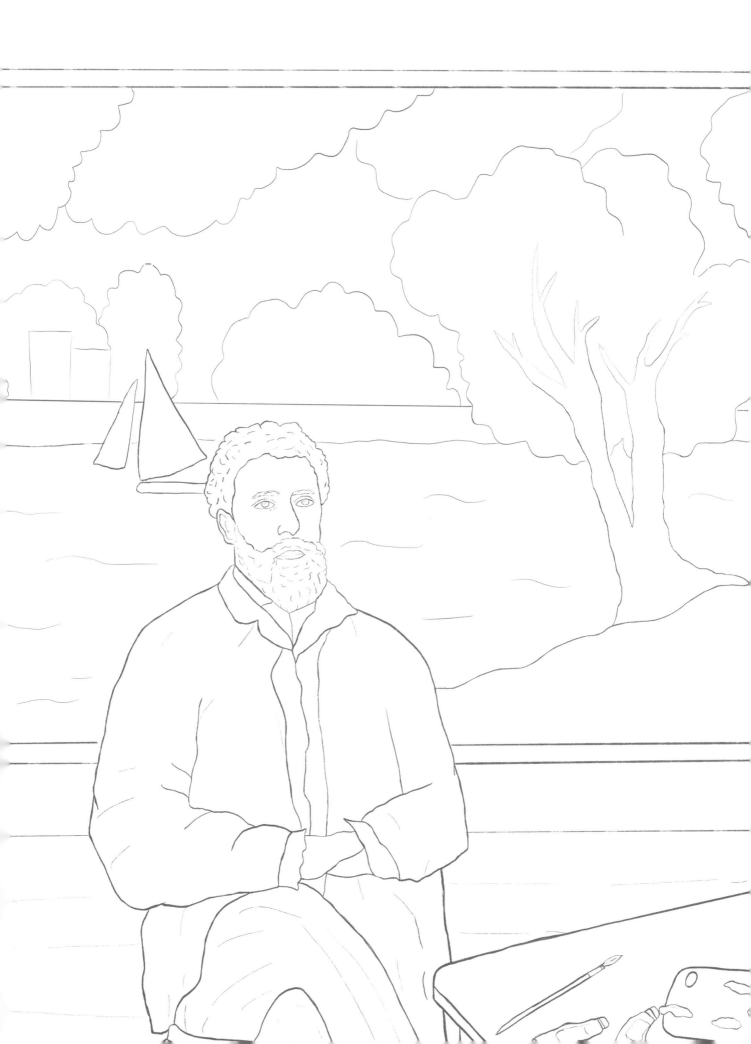

A SUNDAY AFTERNOON ON THE ISLAND OF LA GRANDE JATTE

This work is undoubtedly the most impressive by Seurat. It shows a typical leisurely Sunday scene – a theme often explored by Seurat's Impressionist colleagues – by the River Seine in the suburbs of Paris.

Before committing its final version to a 3-metre-long canvas, Seurat created a series of sketches to study the use of colour. Every inch of the canvas features dozens of pure-colour dots, systematically placed so that when viewed from a distance they merge to convey one of the most well-known scenes in the history of art.

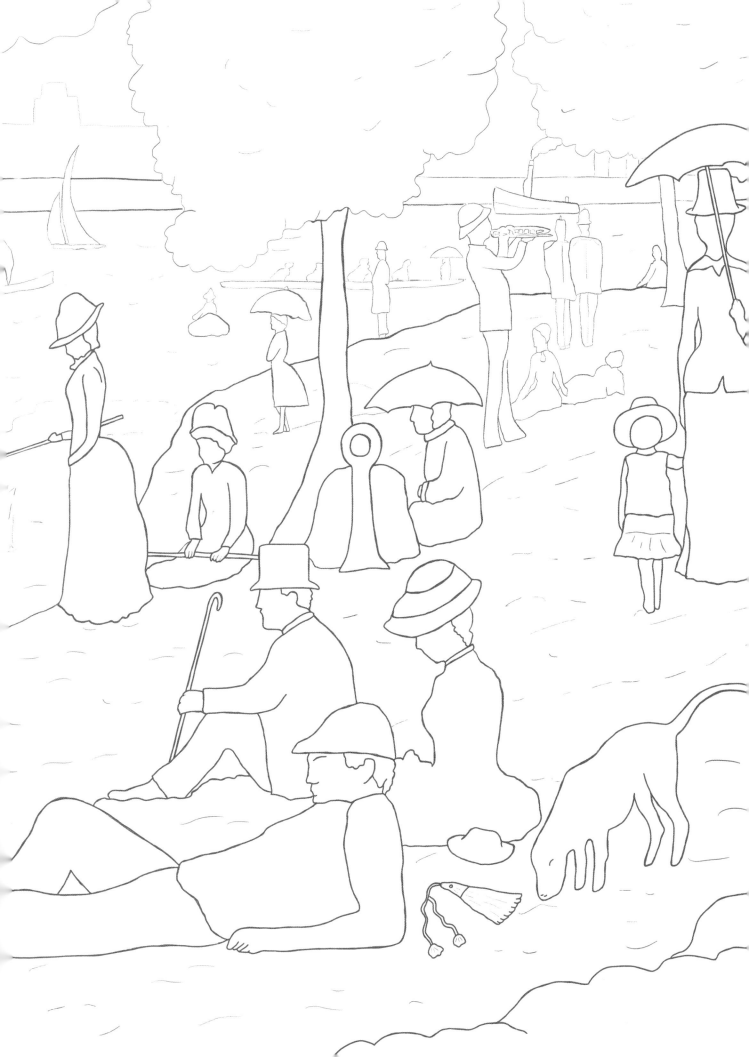

GUSTAV KLIMT
(1862–1918)

While Klimt's art is beautiful and accessible, it is also mysterious and symbolic. Love, passion and desire – as well as anxiety and despair – are conveyed through allegorical scenes, often featuring seductive women. The Viennese artist is best known for his so-called "golden phase" when he began to combine gold leaf with oils. Klimt used gold, which in the Byzantine period was reserved for portraits of kings and saints, to paint scenes with women as the subjects.

THE KISS

Klimt's most iconic work is devoted to love. A man, dressed in a geometric-patterned robe, kisses a woman surrounded by flowers. The scene is intimate, calm and harmonious.

Like other works by Vienna Secession artists – young, radical artists that broke away from the main establishment of Viennese artists to form their own group – *The Kiss* is highly decorative. Each part of the painting is worked in great detail, and the use of gold makes the composition even more outstanding.

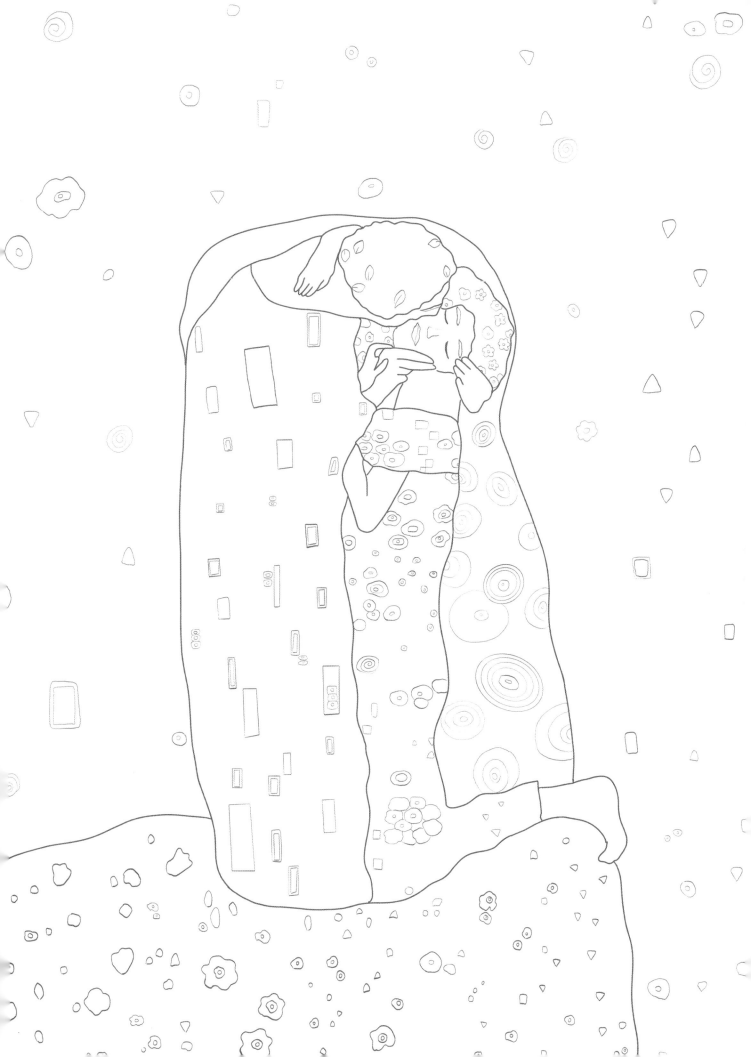

JOAQUÍN SOROLLA
(1863–1923)

Known as the painter of the Mediterranean sunlight, this Spanish artist and follower of the Impressionist movement was a fan of light and the sea. Like his colleagues, Joaquín Sorolla worked *en plein air*. The beach was his favourite studio, and he was not bothered by the sun, wind or salt.

Sorolla was well-known in his country and across Europe because of his characteristic luminism – a nineteenth-century landscape painting style whereby effects of light were used to create atmospheric works. He painted portraits on demand and was even summoned by the Hispanic Society of America, based in New York, to paint 14 murals. Sorolla is considered to be the most important Spanish artist of his time.

WALK ON THE BEACH

This painting shows Sorolla's favourite setting: the beach. His wife, Clotilde, and his oldest daughter, Maria, are the subjects of this leisurely scene depicting summer pleasure in Valencia. We can imagine the artist with his easel and canvas, trying to capture this brief moment while competing with the seaside breeze.

Walk on the Beach was painted at the peak of Sorolla's career. His exhibitions attracted many people and he had plenty of commissions, but he chose to spend his time capturing this intimate scene of his family.

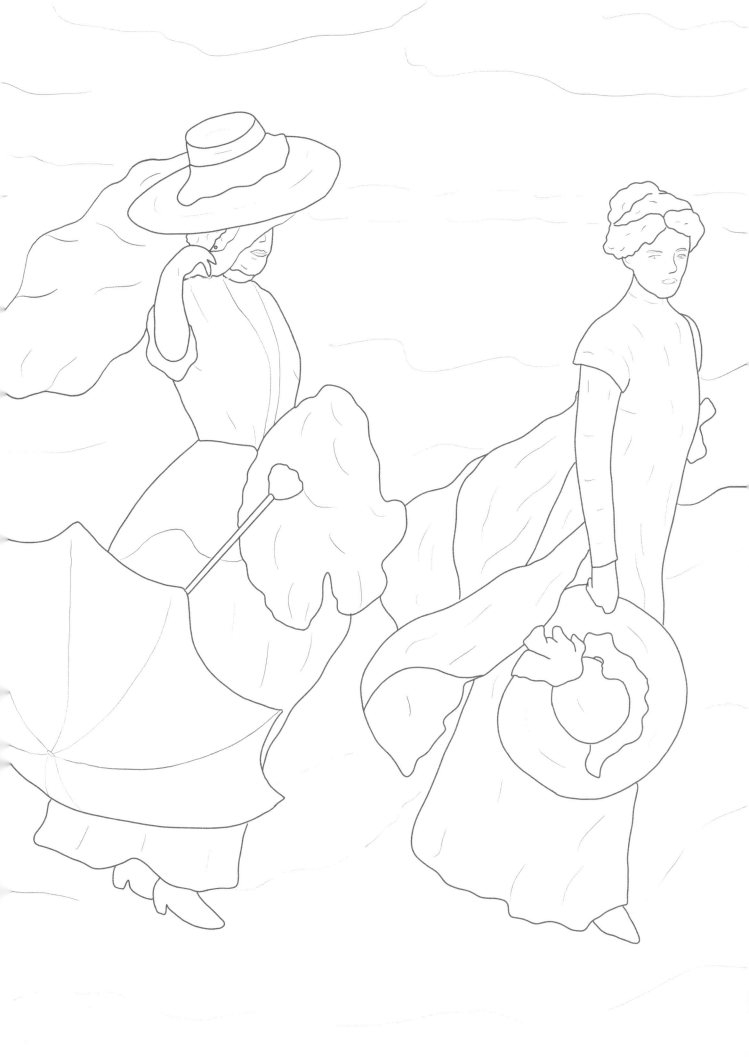

Have you enjoyed this book? If so, find us on
Facebook at **Summersdale Publishers**, on Twitter/X
at **@Summersdale** and on Instagram and TikTok
at **@summersdalebooks** and get in touch.
We'd love to hear from you!

www.summersdale.com